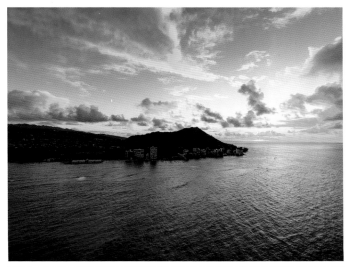

HAWAI'I
The Moods of the Islands

DOUGLAS PEEBLES

Mutual Publishing

Waikīkī, Oʻahu

ISBN: 978-1-949307-08-5
Library of Congress Control Number: 2019943945

First Printing, August 2019

Mutual Publishing, LLC
1215 Center Street, Suite 210
Honolulu, Hawaii 96816
Ph: (808) 732-1709 / Fax: (808) 734-4094
e-mail: info@mutualpublishing.com / www.mutualpublishing.com

Printed in South Korea

I have wanted to do this book for a long time.
It is not really a pictorial representation or island-by-island
tour of Hawai'i. It is more a collection of glimpses of the color,
texture, and moods of Hawai'i. If you live here and are looking,
you will see a few of these scenes each day.

Many of the locations you will recognize, most of the others
could be any island. It is all meant to give just a feeling or
sense of what Hawai'i is. I hope you enjoy it.

— Douglas Peebles

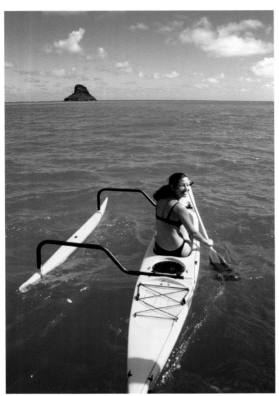

Kāneʻohe Bay, Oʻahu

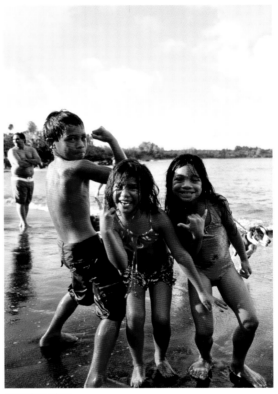

Hāna Bay, Maui

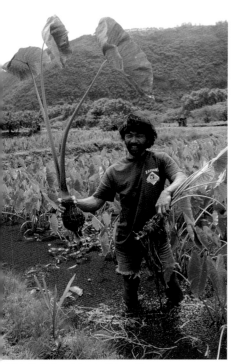

Waipiʻo Valley, Island of Hawaiʻi

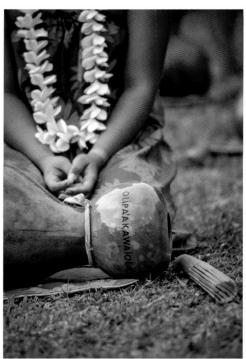

Hāna, Maui

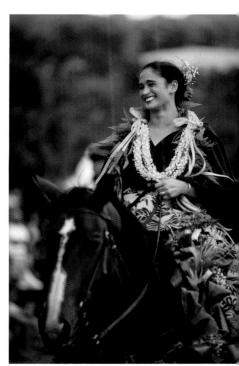

Kamuela, Island of Hawaiʻi

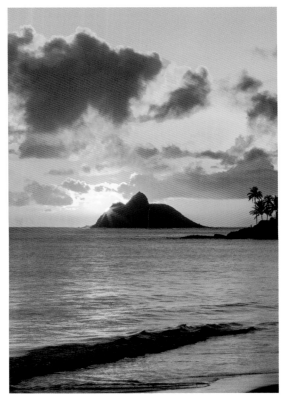

Kailua Beach, Oʻahu

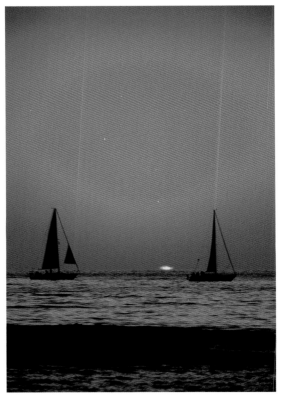

Waikīkī, Oʻahu

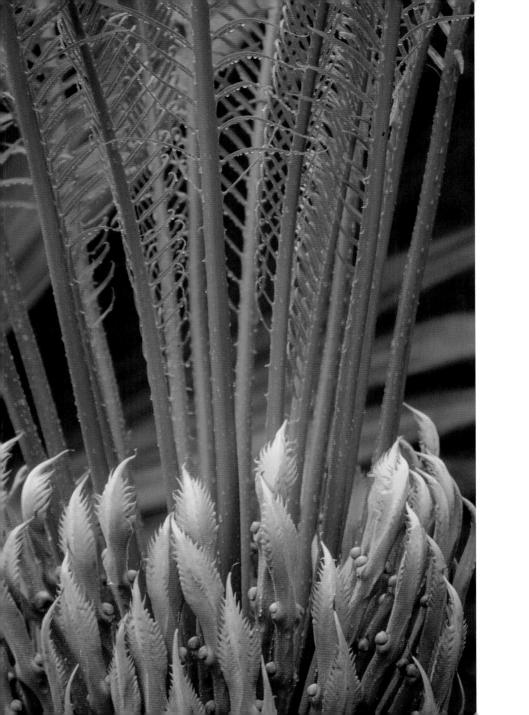

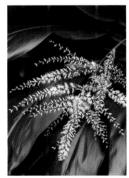

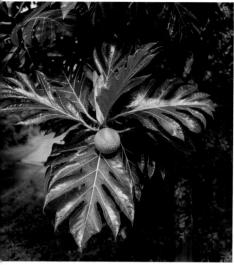

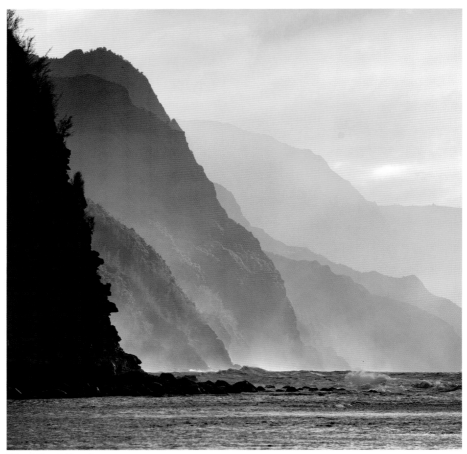

Nāpali Coast, Kauaʻi

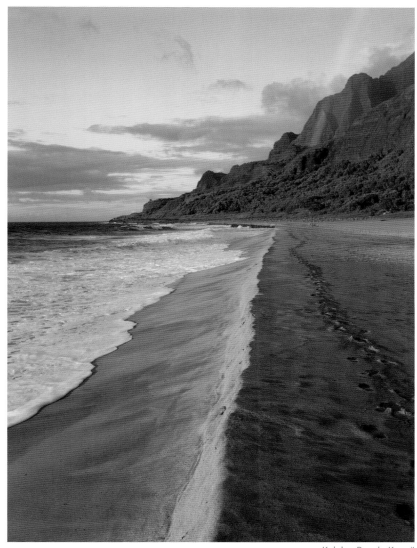

Kalalau Beach, Kaua'i

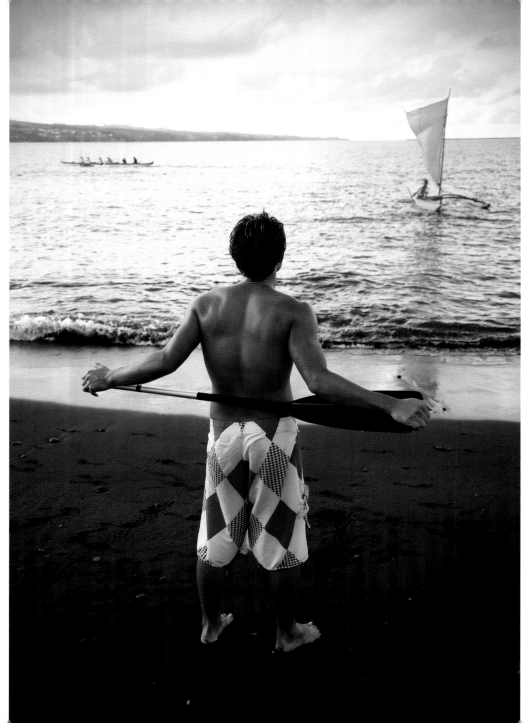

Hilo Bay, Island of Hawai'i

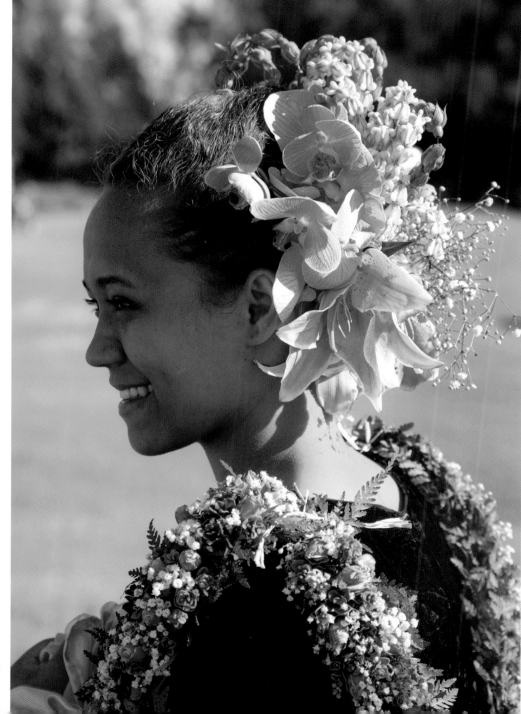

Hawi, Island of Hawai'i

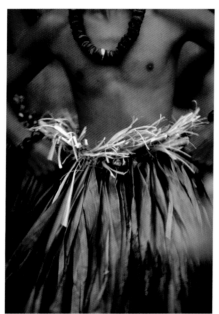

Moloka'i

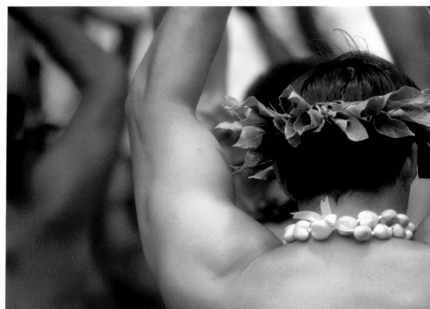

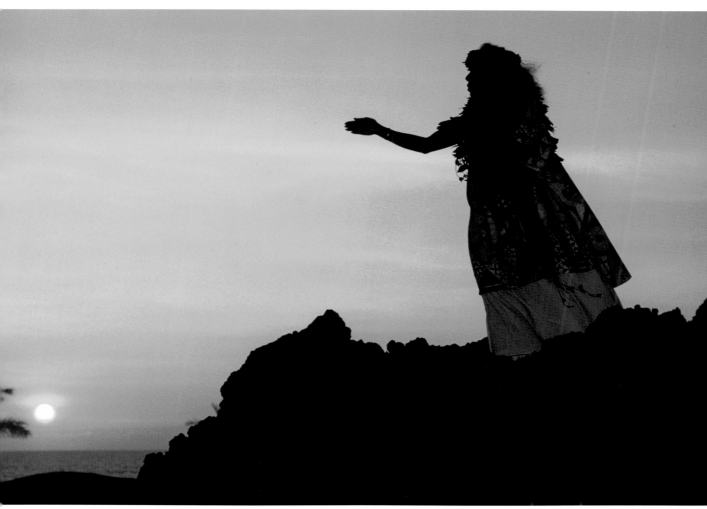

Kohala Coast, Island of Hawai'i

15

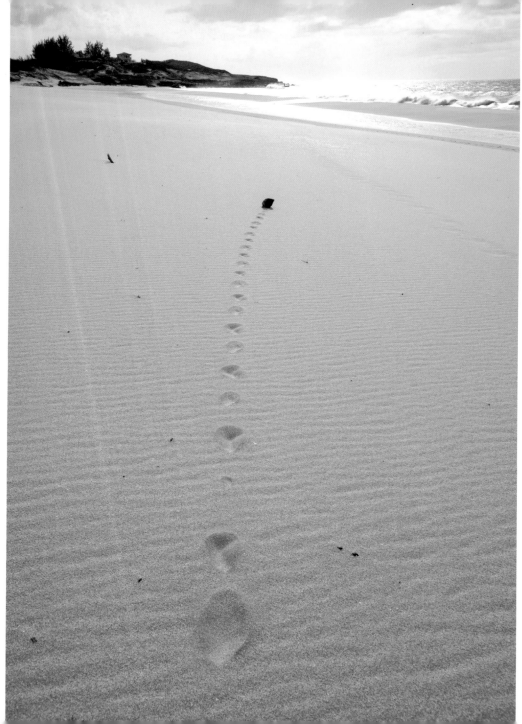

Pāpōhaku Beach, Moloka'i

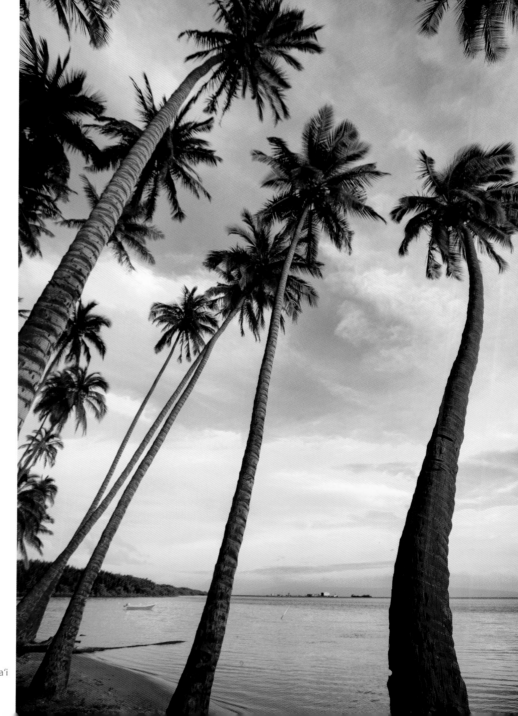

Kapuāiwa Coconut Grove, Molokaʻi

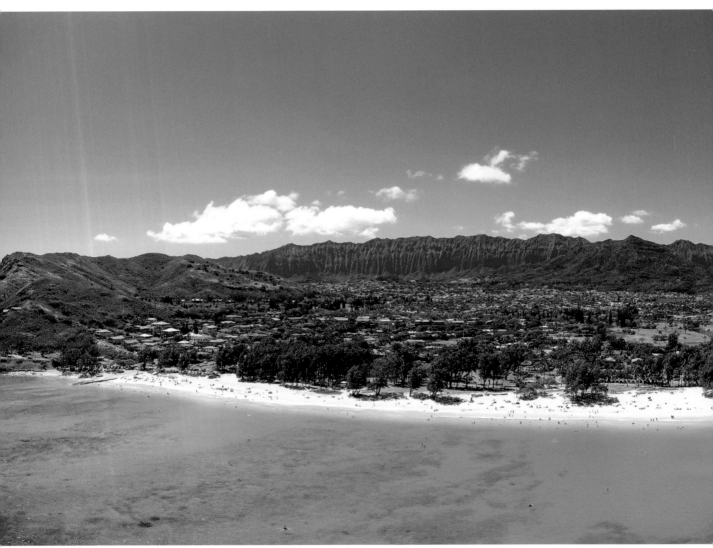

Kailua Beach, Oʻahu

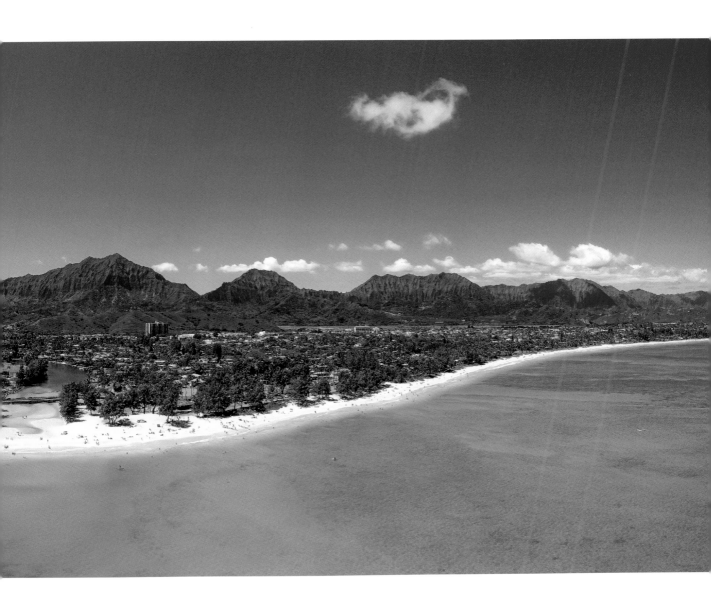

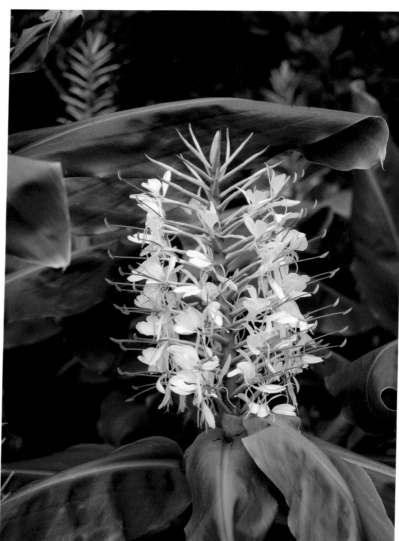

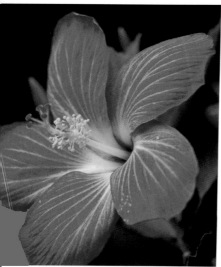

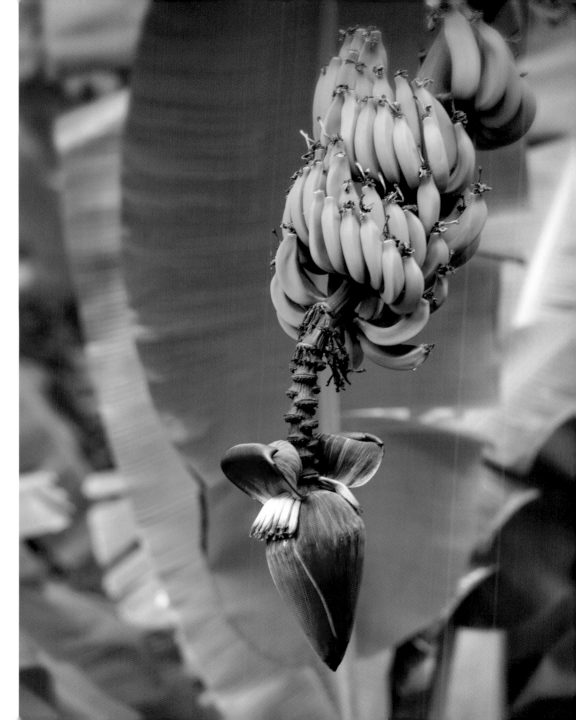

Kailua, Oʻahu

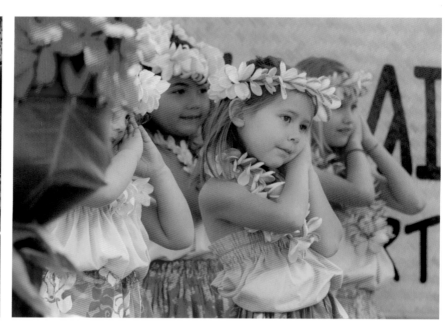

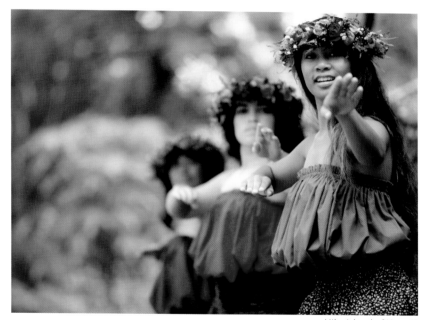

Hilo, Island of Hawai'i

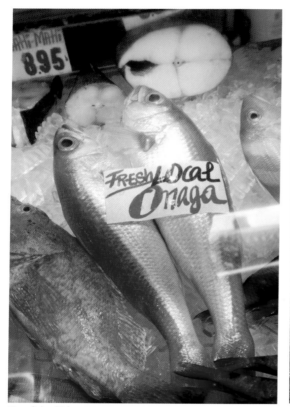

Honolulu, Oʻahu

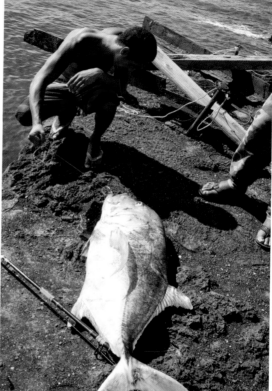

South Point, Island of Hawaiʻi

24

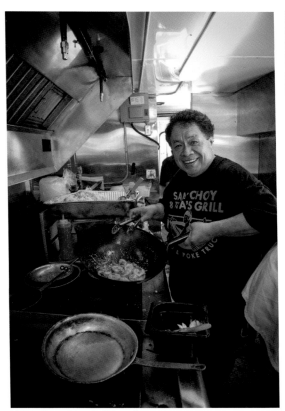

Kailua-Kona, Island of Hawai'i

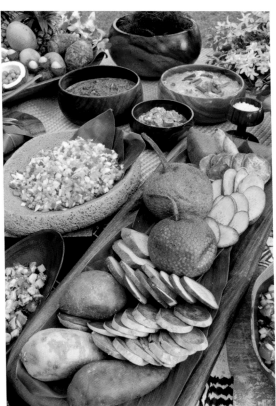

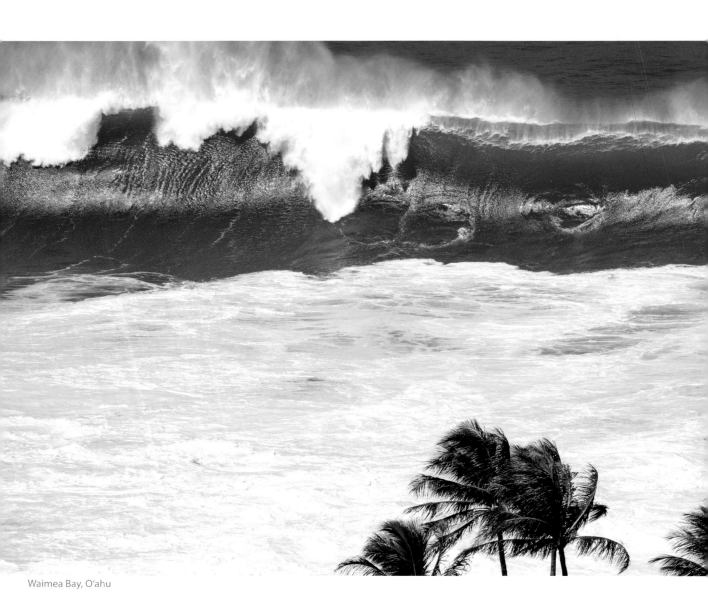

Waimea Bay, Oʻahu

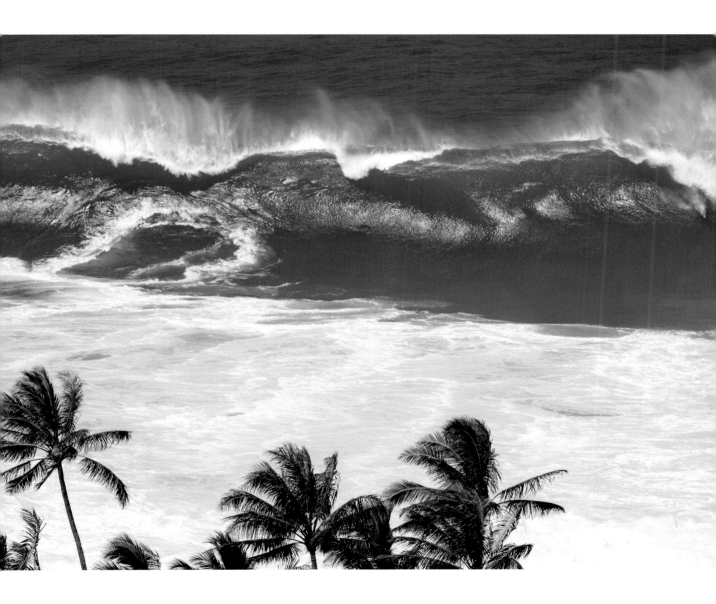

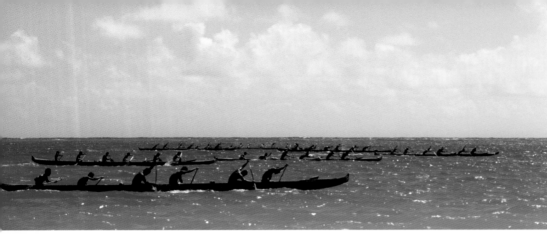

Kailua, O'ahu

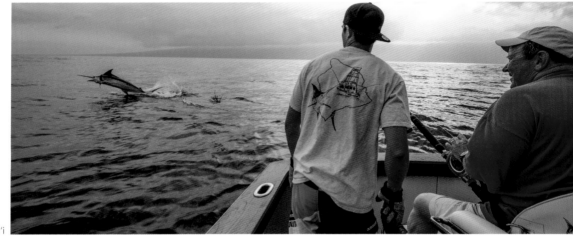

Kailua-Kona, Island of Hawai'i

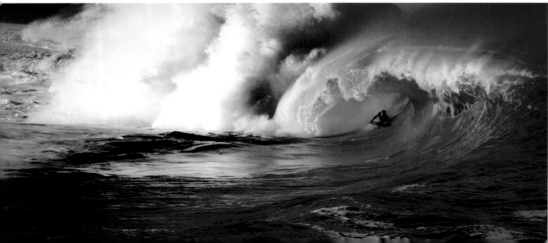

Waimea Bay, O'ahu

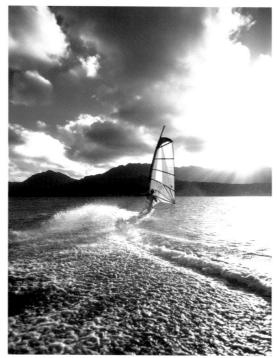

Kāneʻohe Bay, Oʻahu

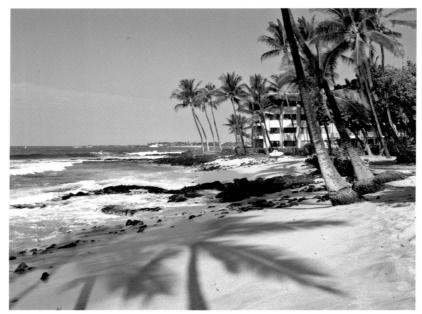

Kailua-Kona, Island of Hawai'i

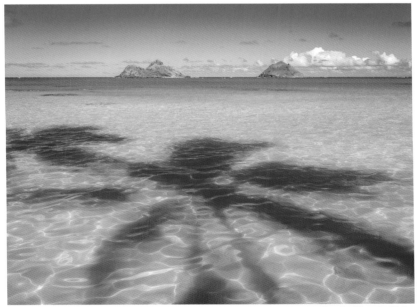

Lanikai Beach, O'ahu

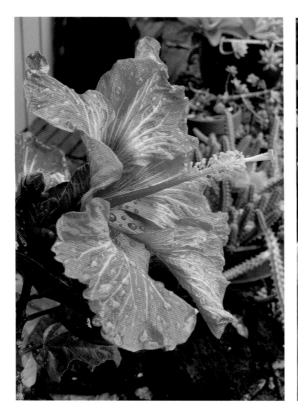
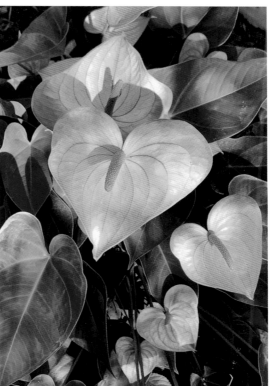

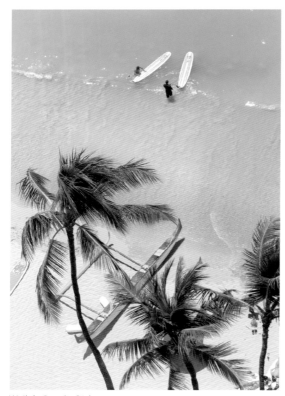

Waikīkī Beach, O'ahu

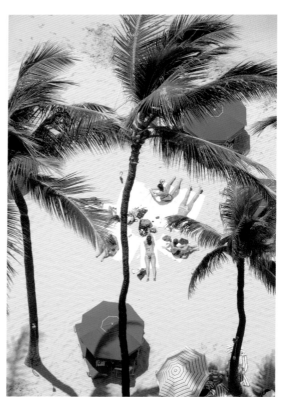

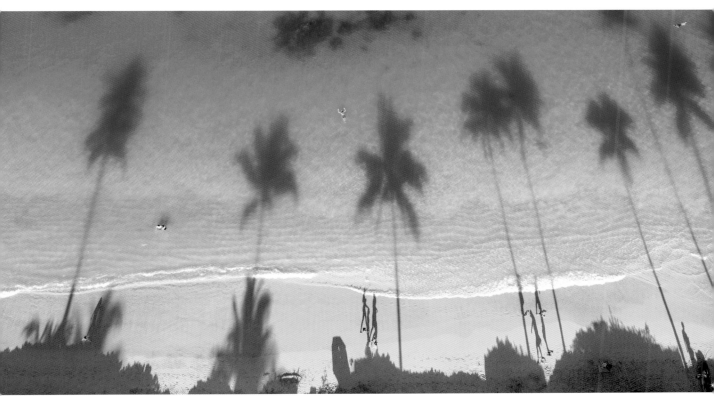

Lanikai Beach, O'ahu

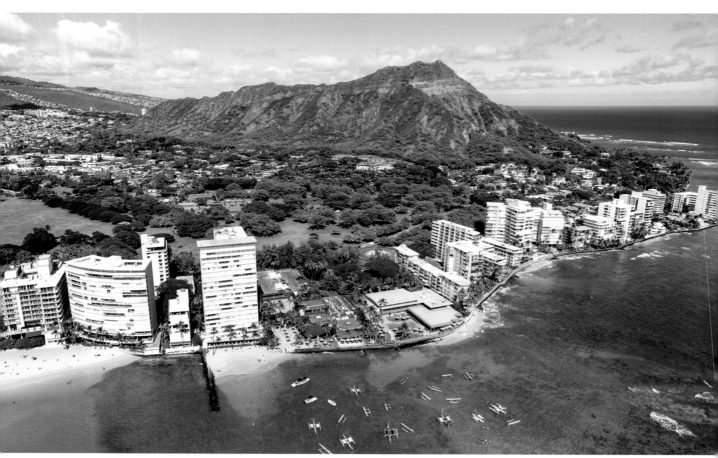

Waikiki, Oʻahu

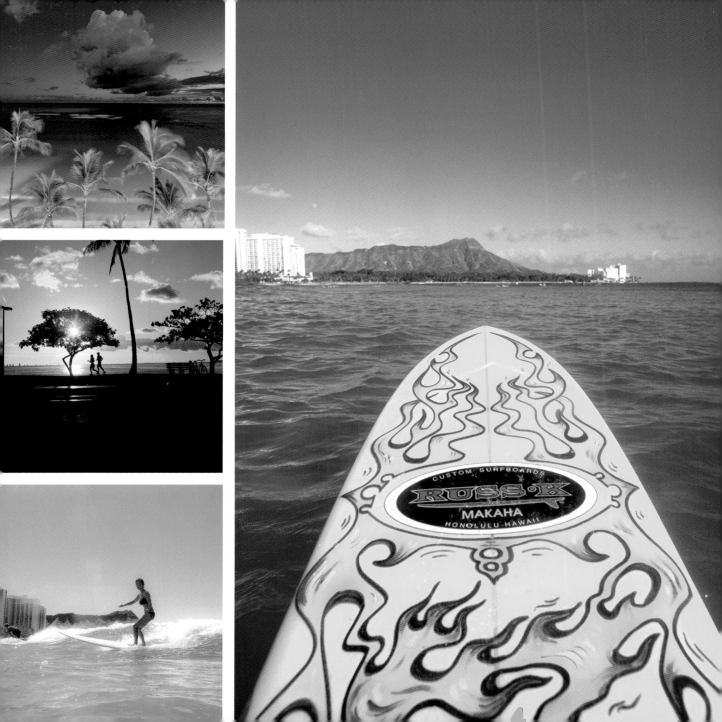

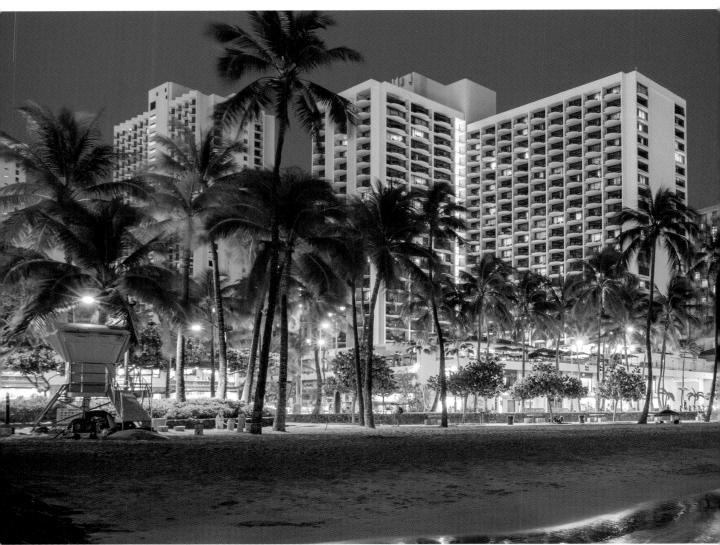

Waikīkī, Oʻahu

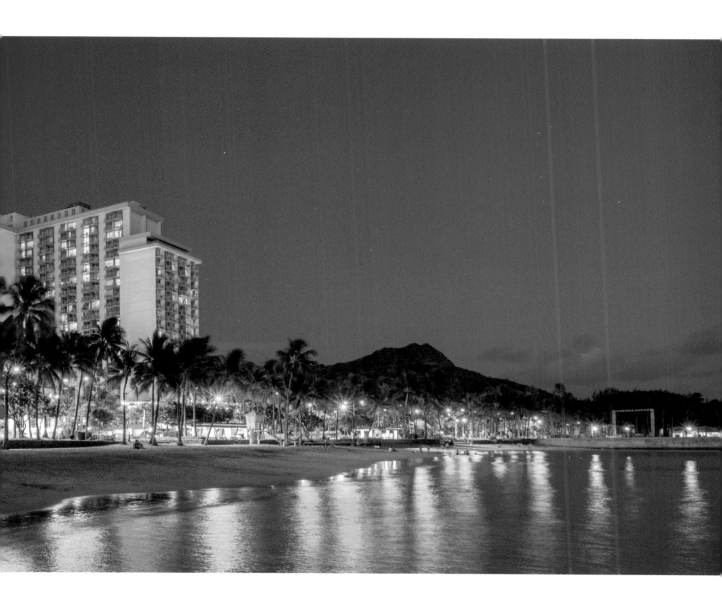

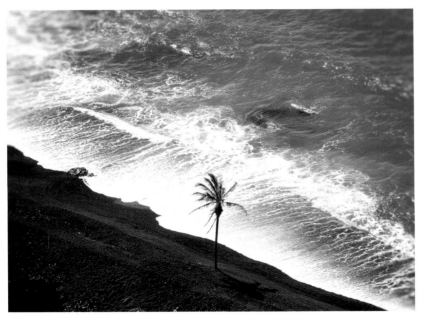

Kohala Coast, Island of Hawai'i

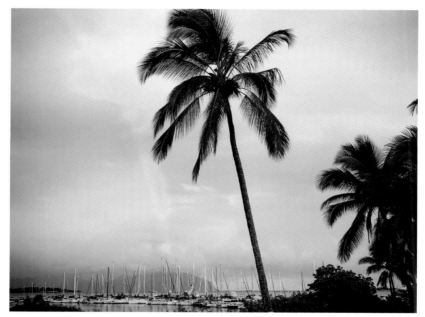

Kāneʻohe Bay, Oʻahu

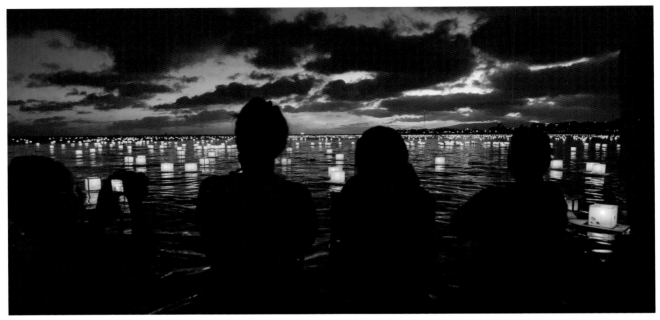

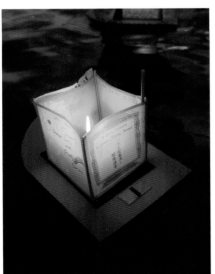

Ala Moana Beach Park, O'ahu

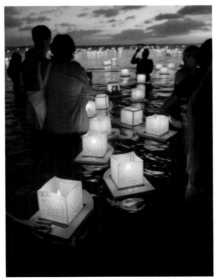

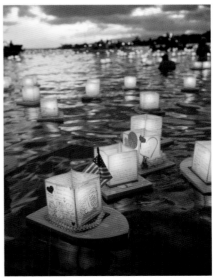

42

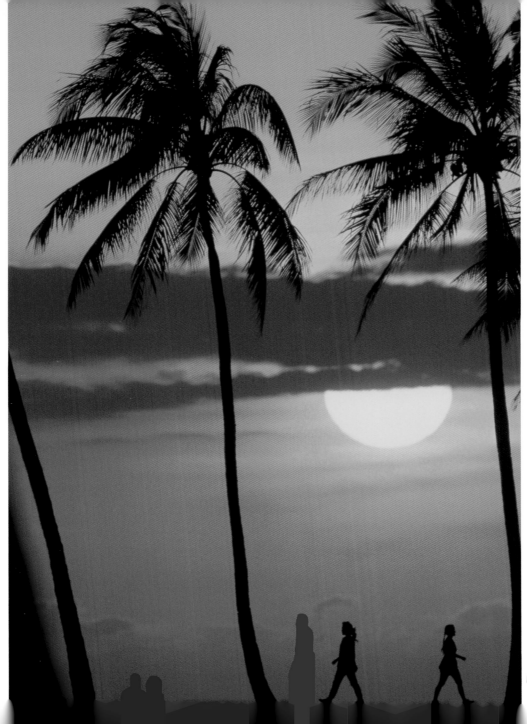

Magic Island, O'ahu

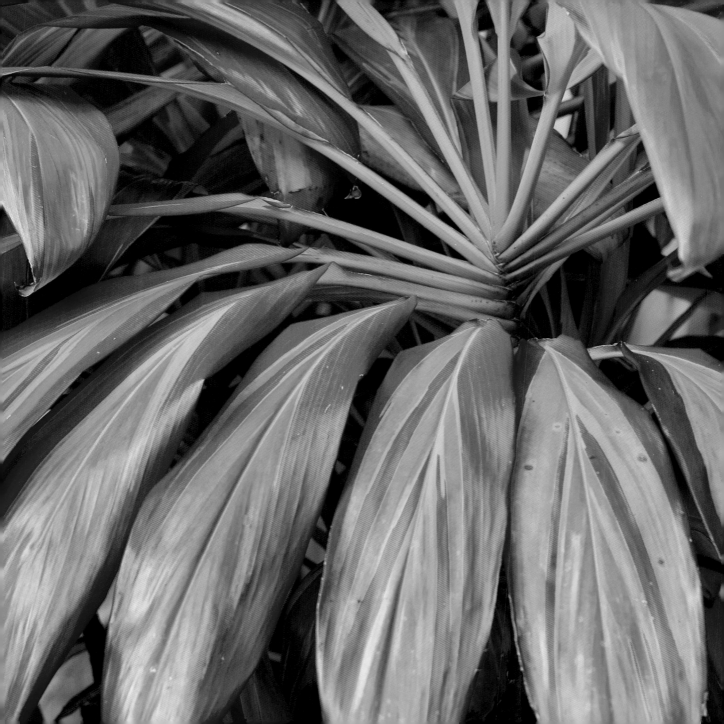

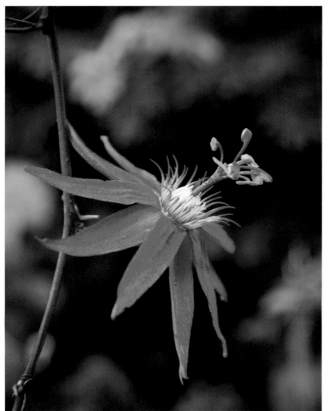
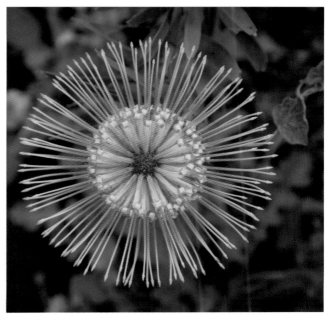

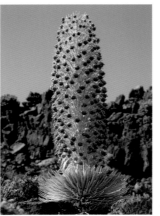
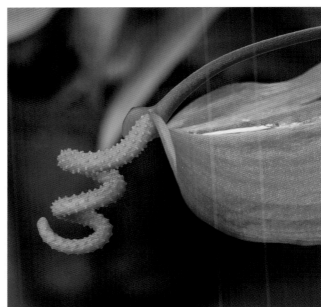

45

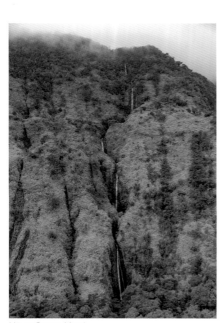

Hāna Coast, Maui

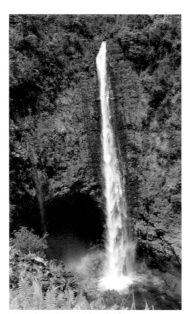

Hāmākua Coast, Island of Hawaiʻi

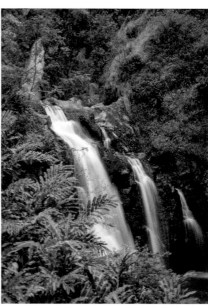

Hāna Coast, Maui

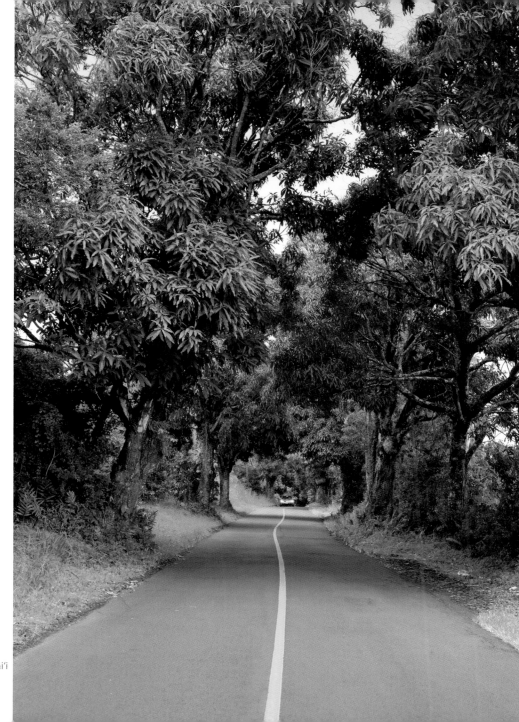

Puna, Island of Hawai'i

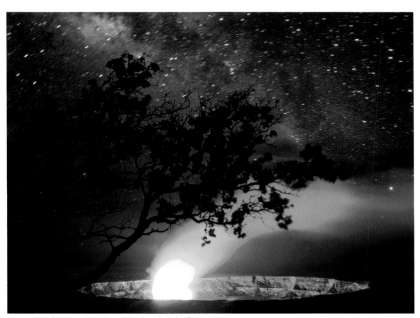

Hawai'i Volcanoes National Park, Island of Hawai'i

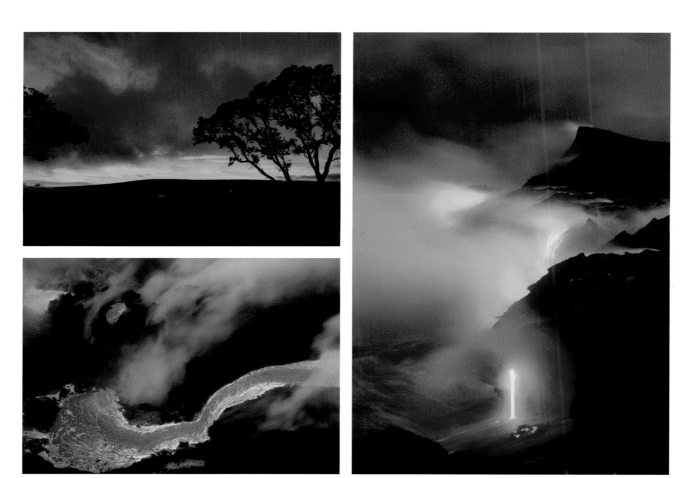

Hawai'i Volcanoes National Park, Island of Hawai'i

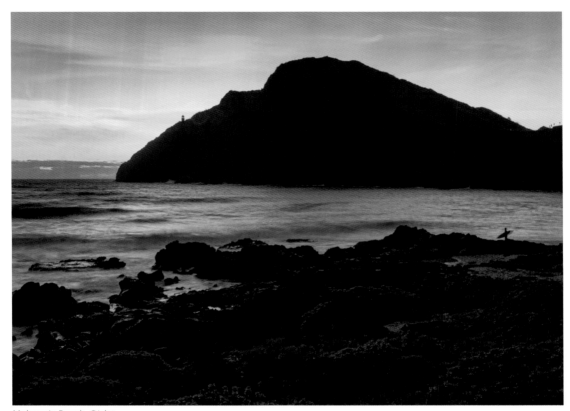

Makapu'u Beach, O'ahu

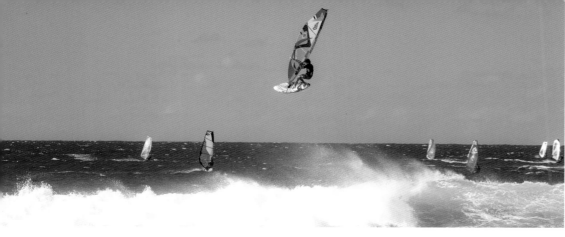

Ho'okipa Beach, Maui

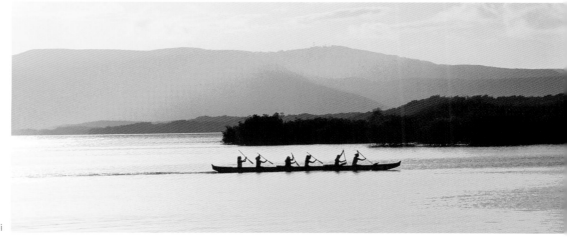

Kaunakakai, Moloka'i

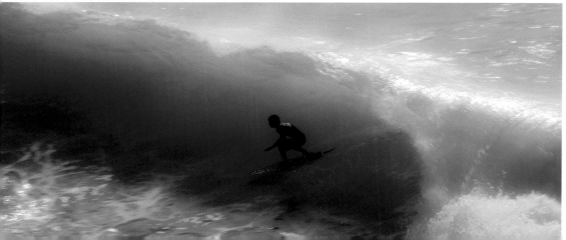

Honolua Bay, Maui

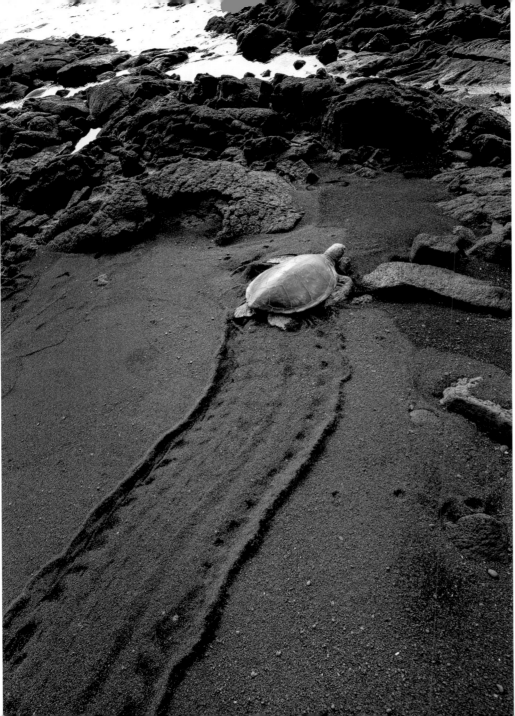

Punalu'u Black Sand Beach,
Island of Hawai'i

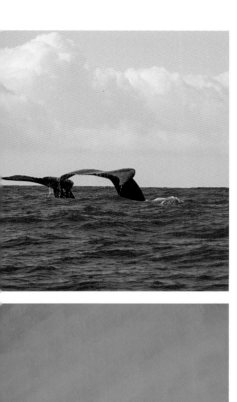

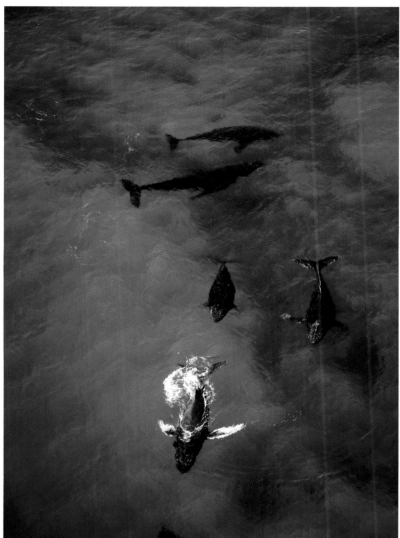

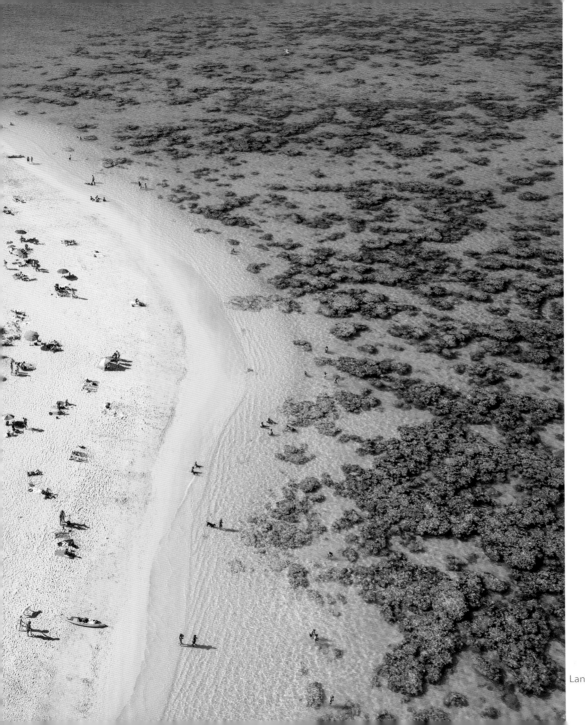

Lanikai Beach, Oʻahu

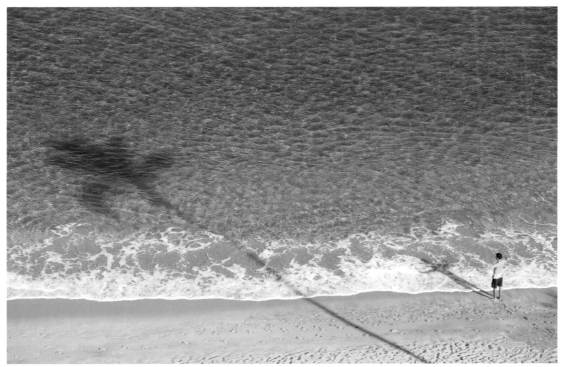

Kā'anapali, Maui

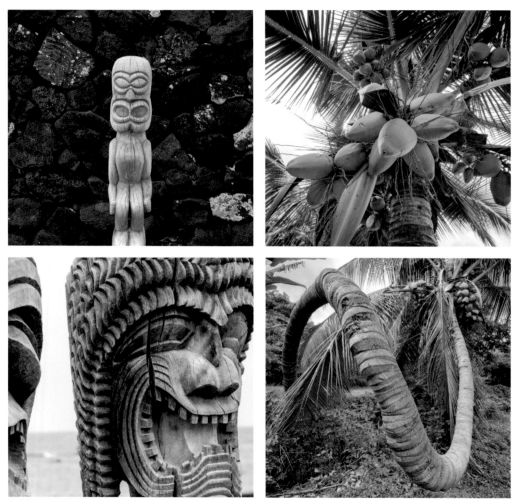

Puʻuhonua o Hōnaunau National Historical Park, Island of Hawaiʻi

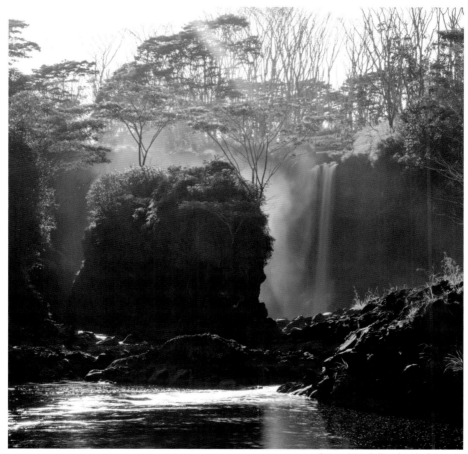

Pe'epe'epe Falls, Island of Hawai'i

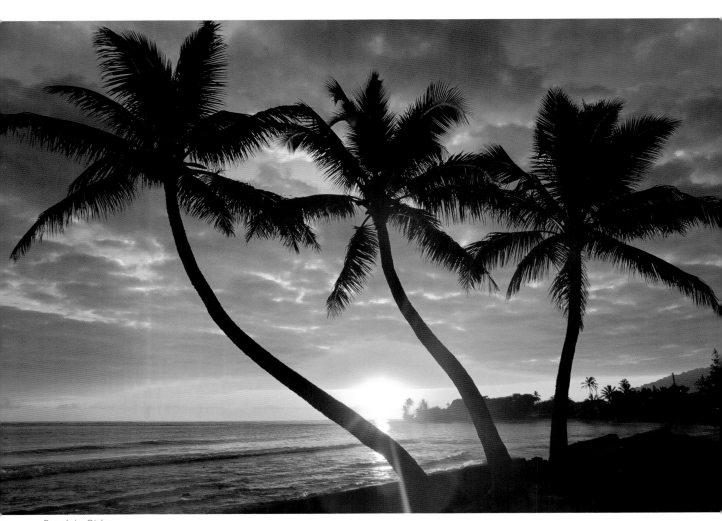

Punalu'u, O'ahu

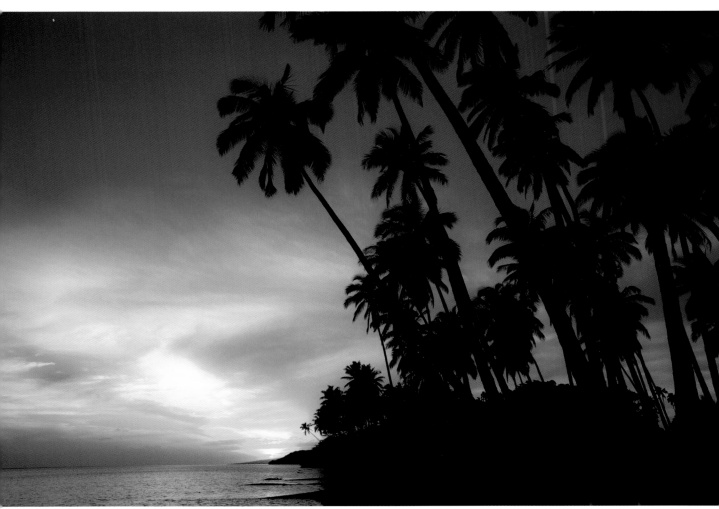

Kapuāiwa Coconut Grove, Molokaʻi

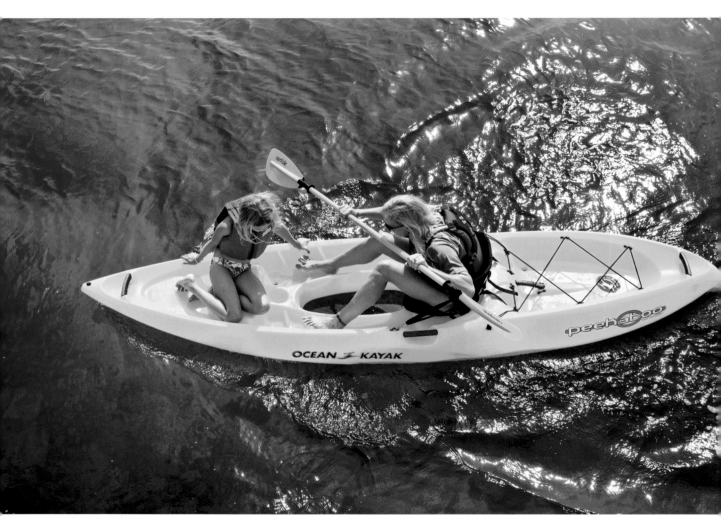

Kāne'ohe Bay, O'ahu

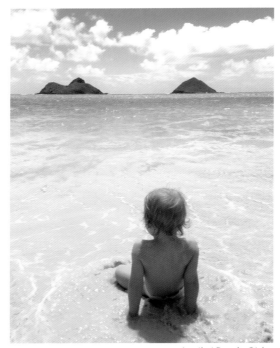

Lanikai Beach, O'ahu

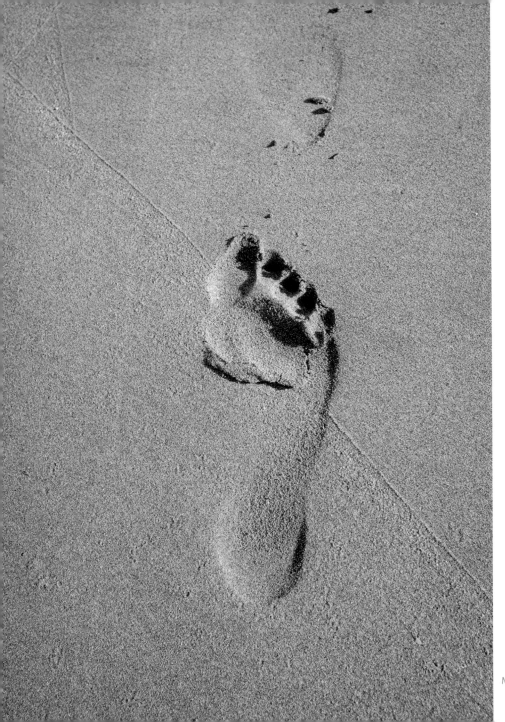

Mākena Beach, Maui

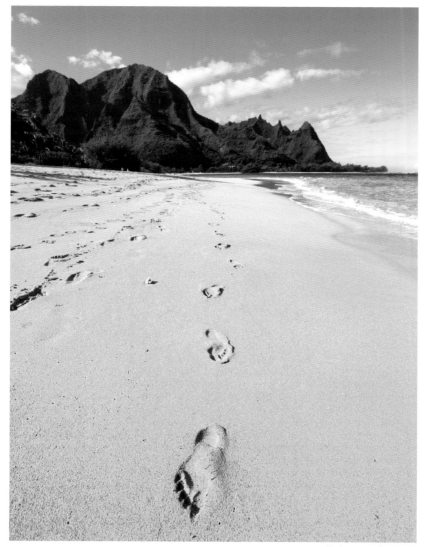

Hā'ena Beach, Kaua'i

Wailea, Maui

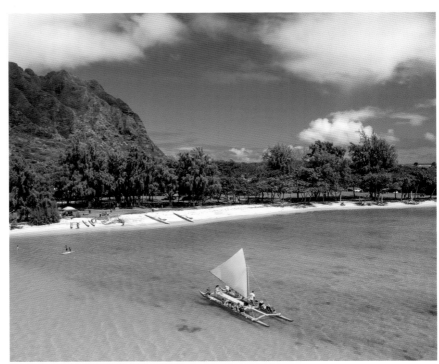

Kāne'ohe Bay, O'ahu

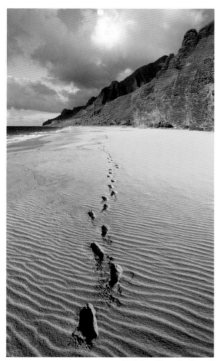

Kalalau Beach, Kaua'i

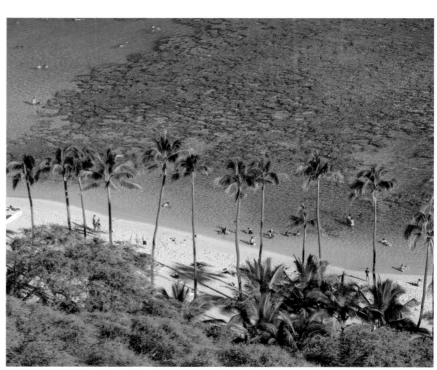

Hanauma Bay, O'ahu

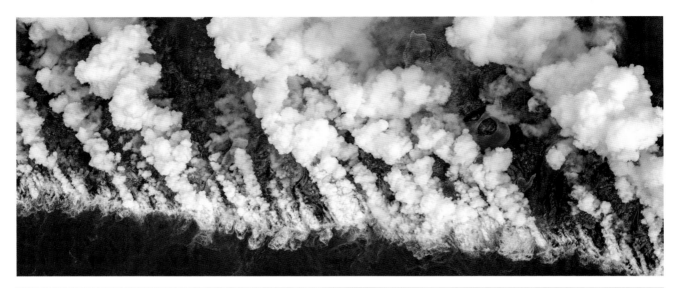

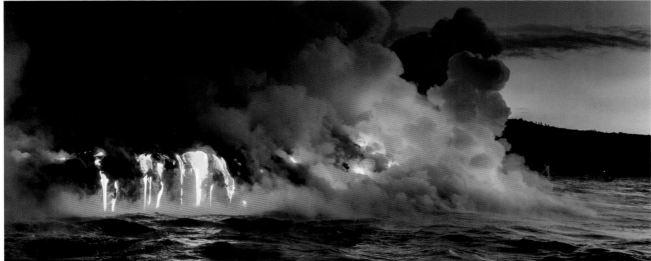

Kīlauea Volcano, Island of Hawai'i

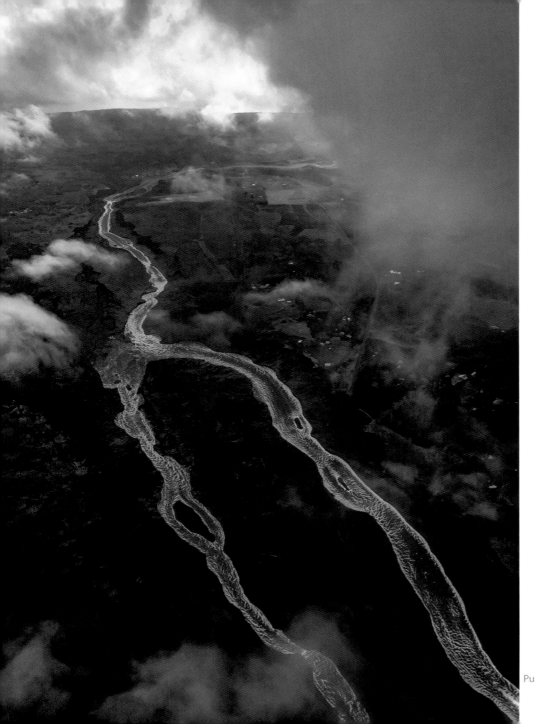

Puna, Island of Hawaiʻi

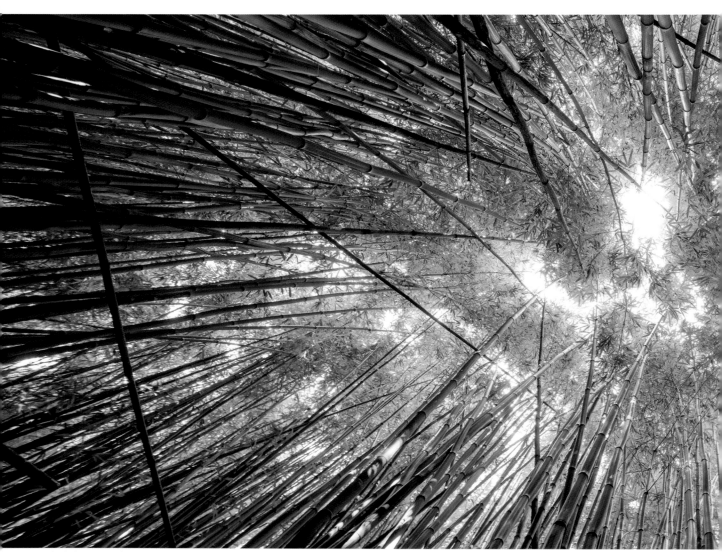

Haleakalā National Park, Maui

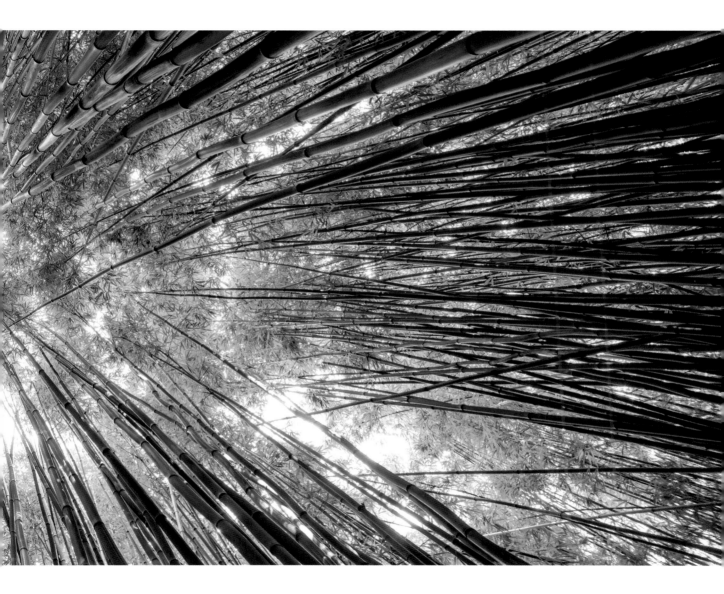

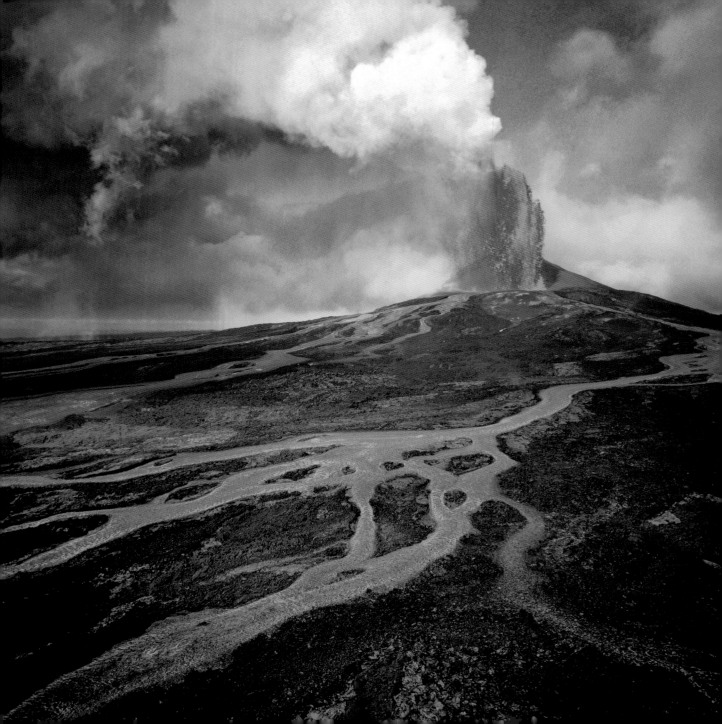

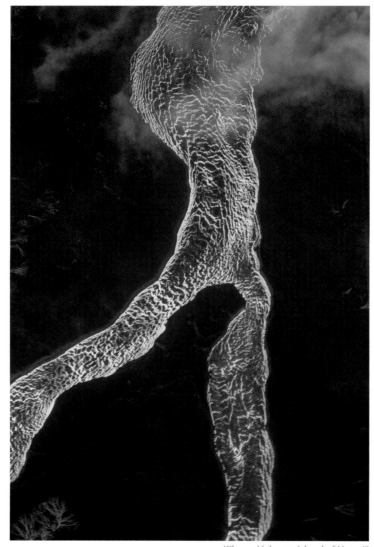

Kīlauea Volcano, Island of Hawai'i

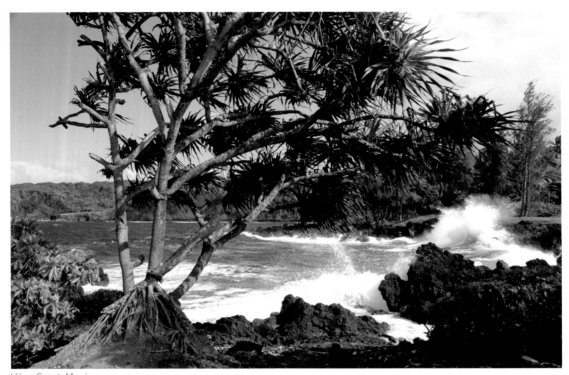

Hāna Coast, Maui

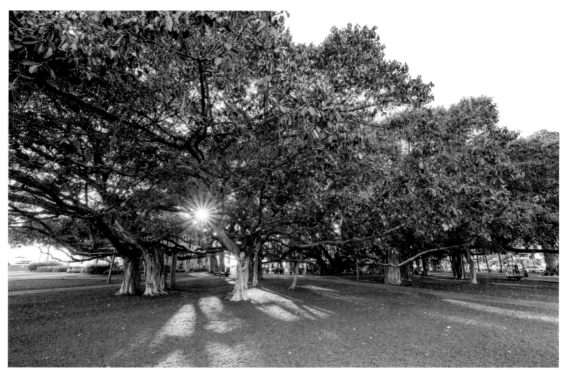

Lahaina, Maui

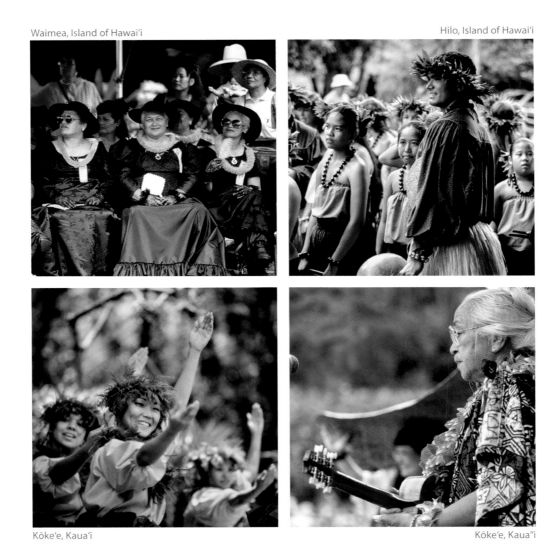

Waimea, Island of Hawai'i

Hilo, Island of Hawai'i

Kōke'e, Kaua'i

Kōke'e, Kaua"i

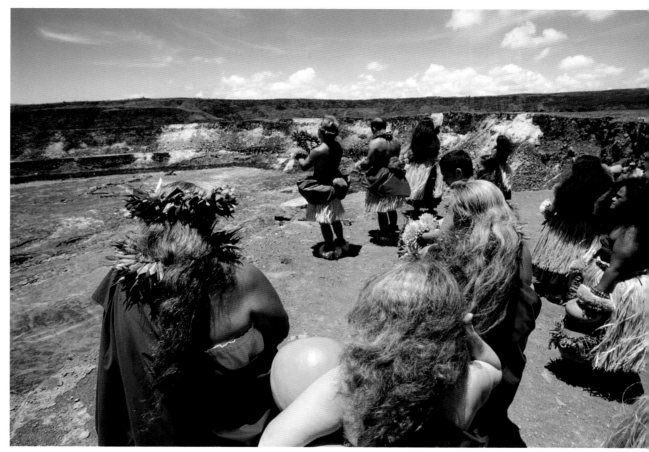

Kīlauea Volcano, Island of Hawai'i

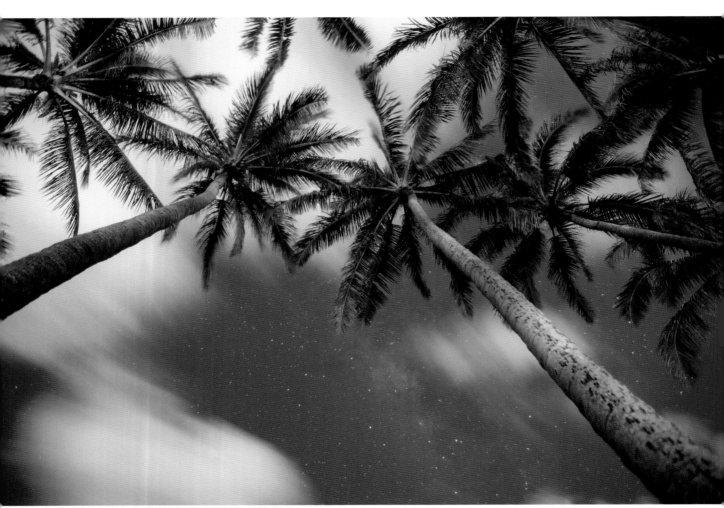

ʻĀina Haina, Oʻahu

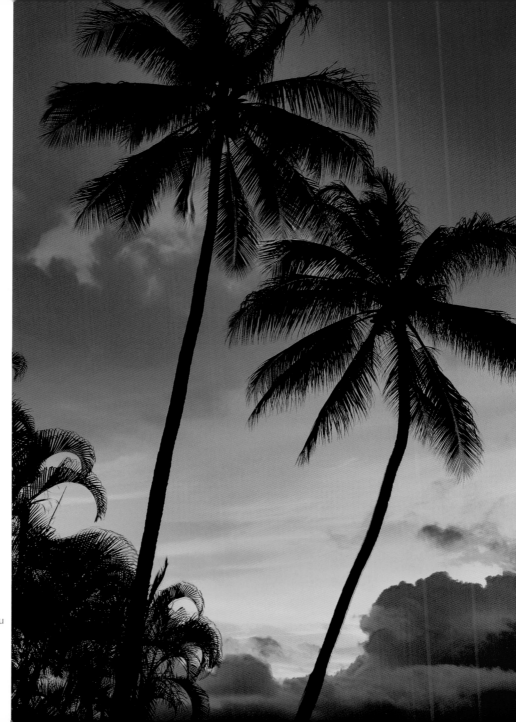

Kāneʻohe, Oʻahu

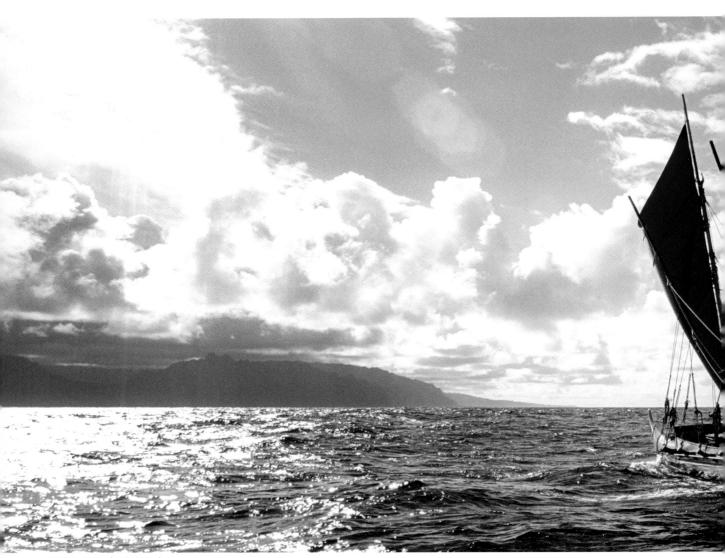

Hōkūlea, Kāneʻohe Bay, Oʻahu

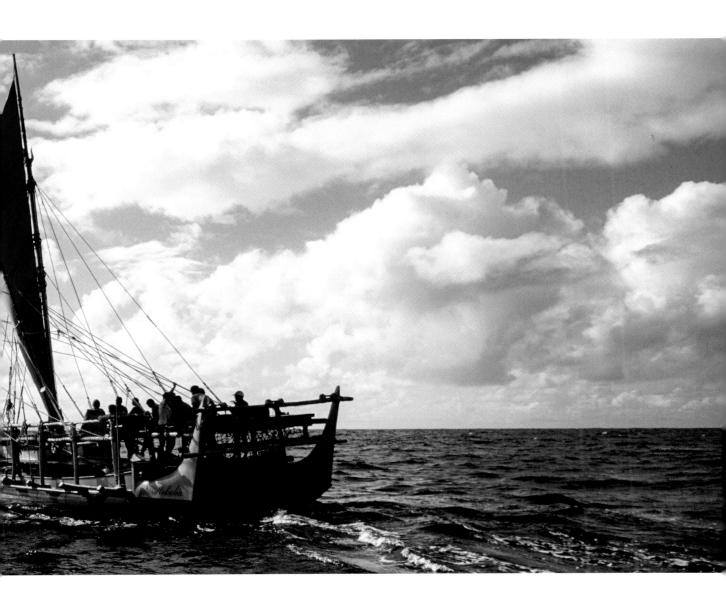

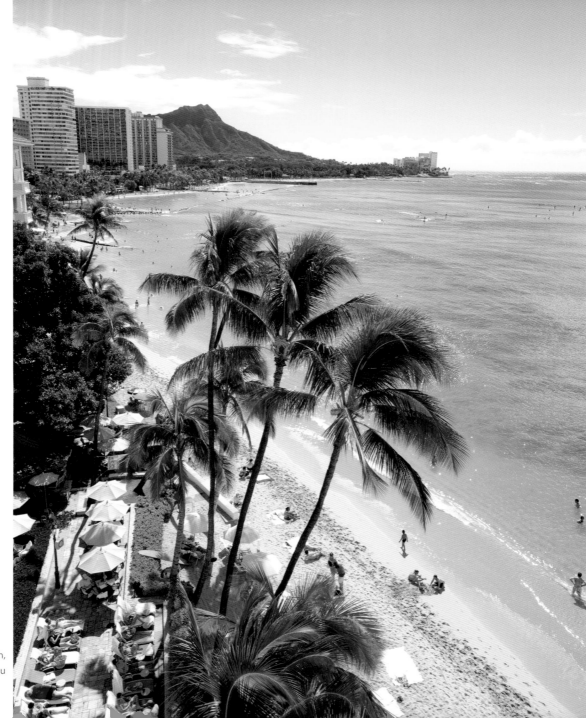

Waikīkī Beach,
Oʻahu

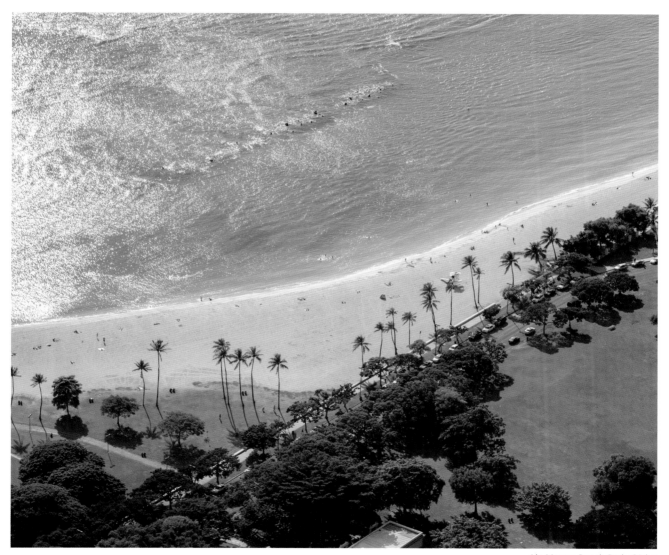

Ala Moana Beach Park, O'ahu

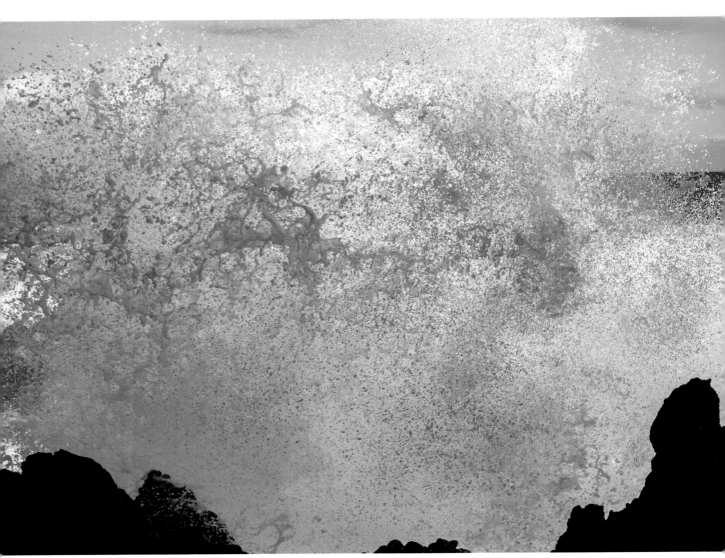

Laupāhoehoe, Island of Hawaiʻi

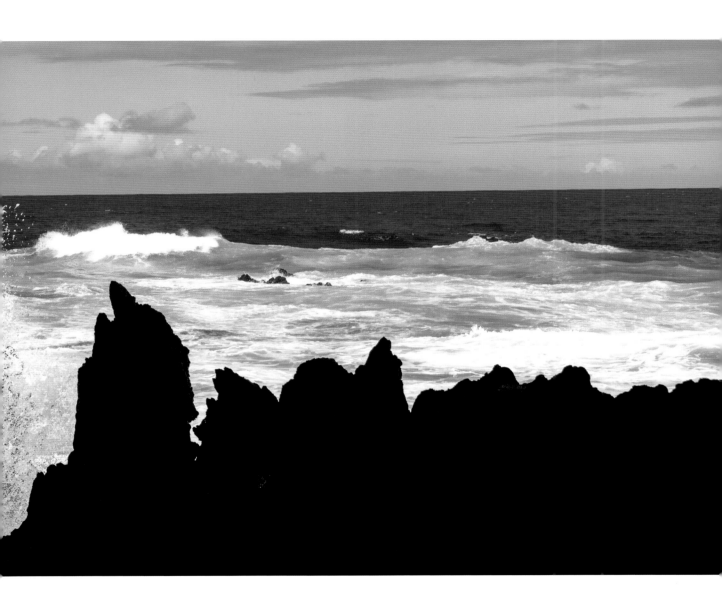

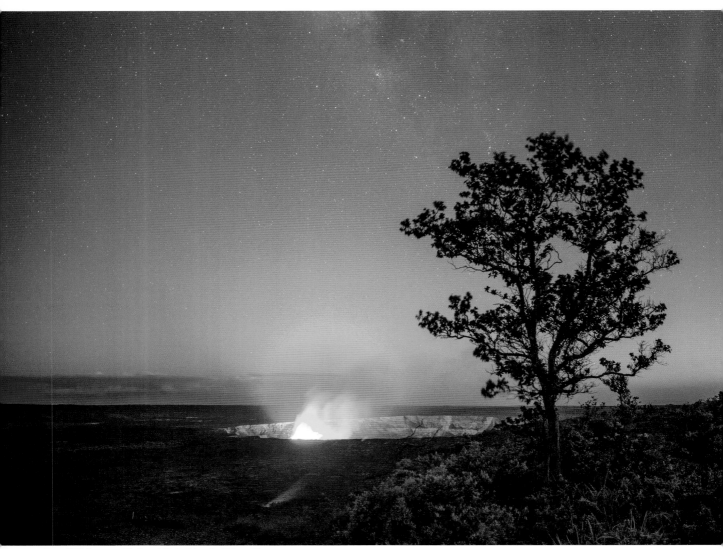

Hawai'i Volcanoes National Park, Island of Hawai'i

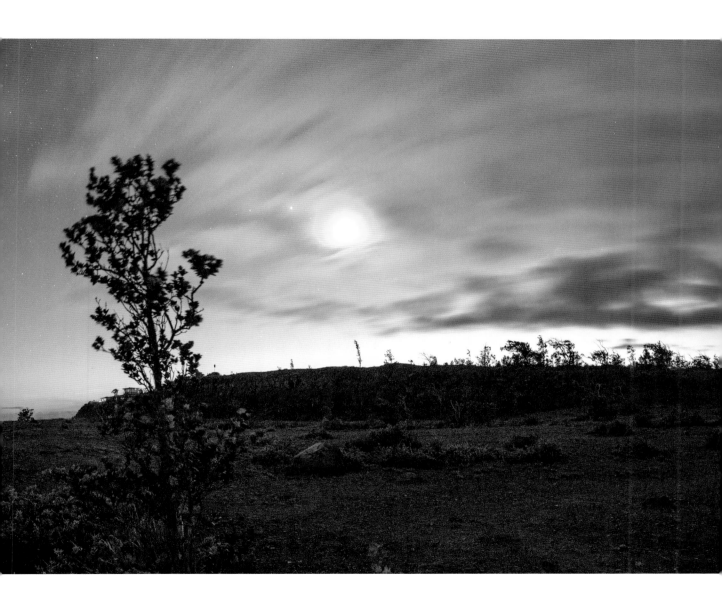

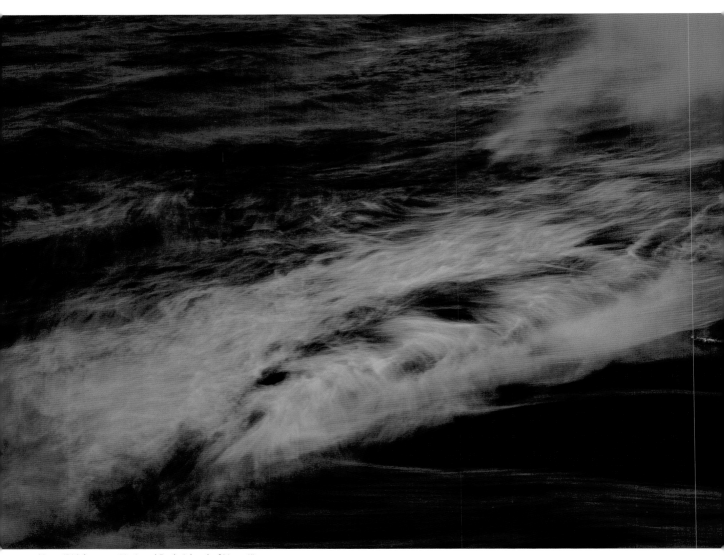

Hawai'i Volcanoes National Park, Island of Hawai'i

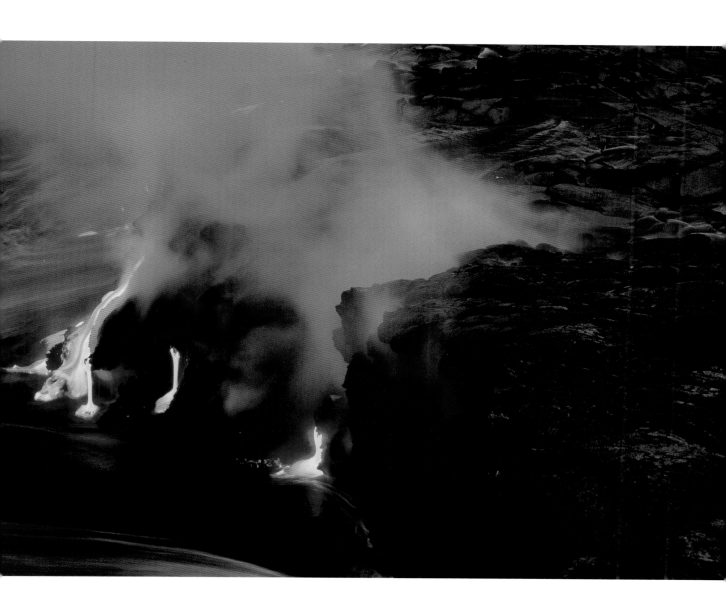

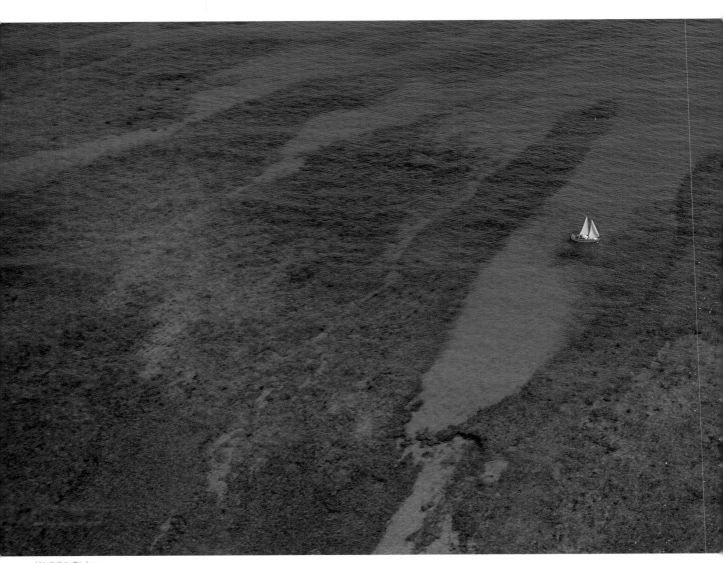

Waikīkī, Oʻahu

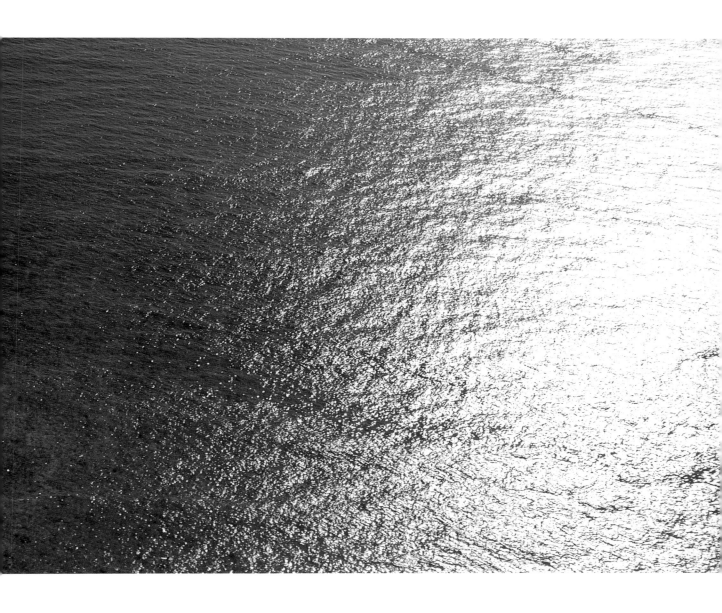

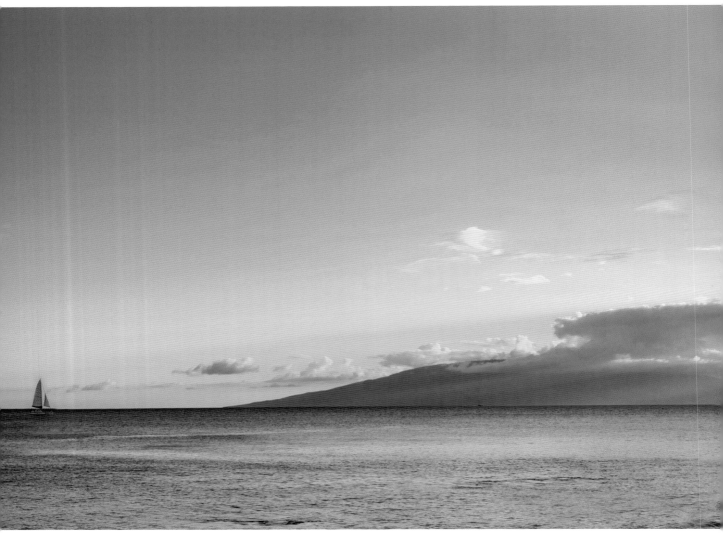

Kā'anapali, Maui

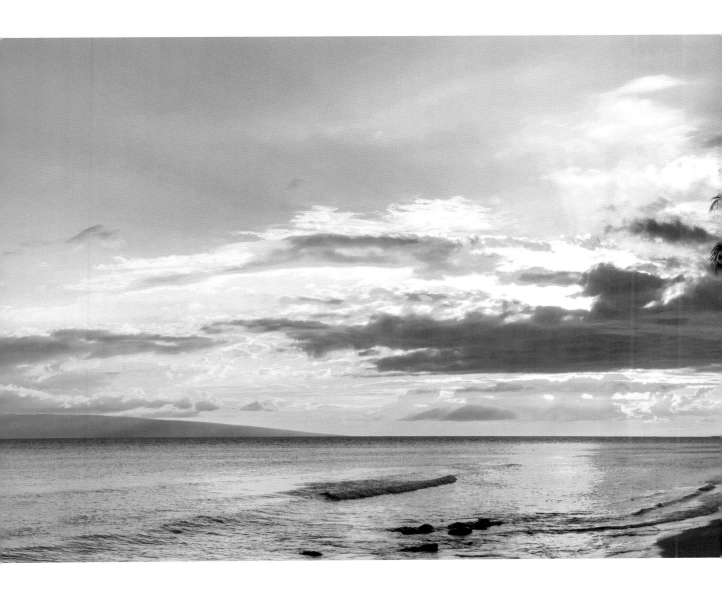

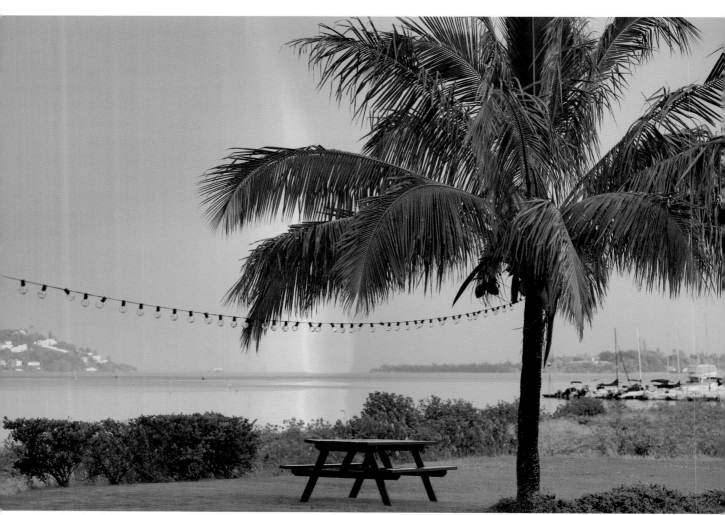

Kāne'ohe Bay, O'ahu

Captions

Pg. 1 Sunrise over Hawai'i's most famous landmark, Diamond Head. The famed Gold Coast area, Kapi'olani Park, and the neighborhood of Kaimukī (center) lie to the left.

Pg. 4 (left) The distinctive shape of Mokoli'i Island, also known as Chinaman's Hat, stands out in the background of an outrigger canoe photo in Kāne'ohe Bay, O'ahu. (right) Kids are always having fun in the water at Hāna Bay, Maui.

Pg. 5 (left) A taro farmer holds up a large sample in a Waipi'o Valley taro patch. (center) This ipu (gourd) is used to create music at a Hāna hula festival. (right) Pā'ū riders are always ready for a parade where half the town seems to be on horseback. Here, riders participate in Waimea's Aloha Week parade in Kamuela, Island of Hawai'i.

Pg. 6 (left) Early sunrise behind the Mokulua Islands seen from Kailua Beach, O'ahu. (right) Sailboats off Waikīkī catch the last glimmer of a sunset.

Pg. 7 Cycads, giant taro, 'ama'u ferns, and ti plants, can be found in Hilo's many gardens.

Pg. 8 Breadfruit trees, red ginger plants, and ornamental banana line the road in Kīpahulu along the Hāna Coast, Maui.

Pg. 9 Banana leaves, giant taro, and monstera plants can all be seen at Limahuli Garden in Hā'ena, Kaua'i.

Pg. 10 The end of the road at Kē'ē Beach offers a great view of the sun setting on the Nāpali Coast.

Pg. 11 Kalalau Beach is a remote part of Kaua'i's Nāpali Coast accessible only by a long hike or kayak paddle.

Pg. 12 Outrigger canoe paddlers always show up in the afternoon to practice in Hilo Bay, Island of Hawai'i.

Pg. 13 A lot of time and flowers go into prepping a pā'ū rider; this rider is getting ready for a parade in Hawi on the Island of Hawai'i.

Pg. 14 The Ka Hula Piko is a three-day festival that happens annually on Moloka'i.

Pg. 15 A Hawaiian chanter at sunset on the Kohala Coast, Island of Hawai'i.

Pg. 16 Footprints of a coconut pushed by high winds at Pāpōhaku Beach, Moloka'i.

Pg. 17 Kapuāiwa, a coconut grove on Moloka'i, was named for King Kamehameha V and was first planted in 1860.

Pg. 18-19 A long stretch of beach with the Ko'olau Mountains in the background in this panoramic of Kailua Beach, O'ahu.

Pg. 20 (top left) The cannonball tree flower is at Foster Botanical Gardens, O'ahu. (right) The Kahili ginger is from Volcano on the Island of Hawai'i, and (bottom left) the red hibiscus can be seen everywhere.

Pg. 21 Bananas are everywhere; these are in Hālawa, Moloka'i.

Pg. 22　A number of hula halau come out every year for the "I Love Kailua" block party, O'ahu.

Pg. 23　Hula dancers performing in a rainforest near Hilo, Island of Hawai'i.

Pg. 24　Onaga (red snapper), seen here at the New Chinatown Market in Honolulu, is one of the most prized bottom fish in Hawai'i. The giant ulua (trevally) was caught from the cliff at Southpoint on the Island of Hawai'i.

Pg. 25　(left) Hawai'i's favorite chef, Sam Choy, cooks poke in Lā'ie, O'ahu. (right) When all the food comes together at a lū'au, it looks like this amazing spread at a Kailua-Kona fest, Island of Hawai'i.

Pg. 26-27　Thirty-foot surf pounds O'ahu's North Shore every winter. This wave is coming into Waimea Bay.

Pg. 28　Outrigger canoe races in Kailua, O'ahu, marlin fishing in Kailua Kona on the Island of Hawai'i, and body boarding the shore break at Waimea Bay on O'ahu are everyday ocean activities.

Pg. 29　When the wind is up, windsurfers come out, especially at Kāne'ohe Bay, O'ahu.

Pg. 30　Known as the place where body boarding started, Honl's Beach in Kailua Kona, Island of Hawai'i, is also popular with surfers.

Pg. 31　When the seas are calm and the sun is shining, it is hard to imagine a more idyllic spot than Lanikai Beach, O'ahu.

Pg. 32　Red ginger and bird-of-paradise, Hanalei, Kaua'i, are two of Hawai'i's more common tropical flowers.

Pg. 33　Red hibiscus and pink anthurium from a private garden in Kāne'ohe, O'ahu.

Pg. 34　Surfing and sun tanning are the two most popular activities at Waikīkī Beach, O'ahu.

Pg. 35　Late afternoon sun means long shadows and fewer people on Lanikai Beach, O'ahu

Pg. 36　Sitting side-by-side, the Outrigger Canoe Club and Elks Club are at the center of Waikīkī's Gold Coast on O'ahu.

Pg. 37　Scenes of sunsets and surfing are everyday occurrences in Waikīkī.

Pg. 38-39　The Waikīkī skyline lights up at twilight with Diamond Head's silhouette at the far right.

Pg. 40　This lone palm tree on Kawaiki Black Sand Beach on the Kohala Coast, Island of Hawai'i, has been there for decades. A short hike over the lava takes you there.

Pg. 41　On many mornings, rainbows form in Kāne'ohe Bay, O'ahu. This one is right behind the Kaneohe Yacht Club.

Pg. 42　The Lantern Floating Festival is held every year at the end of May at Ala Moana Beach Park, O'ahu. The ceremony remembers those who are gone from our lives.

Pg. 43　Sunset at Magic Island, Ala Moana Beach Park in Waikīkī, brings out hikers, bikers, and those who just want to relax and people watch.

Pg. 44　The ti plant found throughout the Pacific Islands has many cultural and practical uses. This one is in Waipi'o Valley, Island of Hawai'i.

Pg. 45　Maui's flowers include the passion flower, silversword, protea, croton, and torch ginger.

Pg. 46 Waterfalls abound throughout the Islands. (left to right) Ko'olau Forest Reserve on the Hāna Coast, Maui; 'Akaka Falls State Park on the Hāmākua Coast, Island of Hawai'i; and Waikani Falls, aka Three Bears, on the Hāna Coast, Maui.

Pg. 47 The mango tree tunnel in Puna, Island of Hawai'i was fortunately spared during the recent eruption of Kīlauea Volcano.

Pg. 48 The Milky Way is seen over Halema'uma'u Crater on Kīlauea Volcano, Hawai'i Volcanoes National Park, Island of Hawai'i.

Pg. 49 The lava from Kīlauea Volcano makes its way to the shores increasing the size of the island, Hawai'i Volcanoes National Park, Island of Hawai'i.

Pg. 50 A lone surfer is the first to enter the water at sunrise on Makapu'u Beach, O'ahu.

Pg. 51 Windsurfing at Ho'okipa, Maui, outrigger canoe paddling at Kaunakakai, Moloka'i, and surfing at Honolua Bay in Kapalua, Maui, are three of Hawai'i's favorite water sports.

Pg. 52 This sea turtle is making its way back into the ocean at Punalu'u Black Sand Beach, Island of Hawai'i.

Pg. 53 Hawai'i's whales are part of a North Pacific humpback population that migrates between Alaska and the Islands. Thanks to federal protection, this community—once reduced to a few hundred—now numbers in the low thousands.

Pg. 54 This bird's eye view of Lanikai Beach shows how well the coral has rebounded in this area.

Pg. 55 Kā'anapali's golden morning sand awaits the day's beachgoers.

Pg. 56 Tikis and coconuts can be found throughout Pu'uhonua o Hōnaunau National Historical Park, Island of Hawai'i. Formally known as the City of Refuge, it was a place where those who had broken a kapu could go to escape punishment or death.

Pg. 57 Pe'epe'e Falls is about a mile upstream from Rainbow Falls on the Wailuku River in Hilo, Island of Hawai'i. A trail leads down, but it is very difficult to navigate.

Pg. 58 These three coconut palms are on the side of the road in Punalu'u, O'ahu.

Pg. 59 Kapuāiwa Coconut Grove at sunset is one of Moloka'i's most beautiful sights.

Pg. 60 The clear blue waters near the sandbar in Kāne'ohe Bay are perfect for kayaking.

Pg. 61 This boy is not quite ready to swim out, but it seems like he is thinking about it. Lanikai Beach with Mokulua Islands on O'ahu.

Pg. 62 A footprint in the sand at Maluaka Beach in Mākena, Maui.

Pg. 63 Hā'ena Beach, on the North Shore of Kaua'i, is deserted early in the morning.

Pg. 64 (left) Resort homes and coconut palm trees line the shore of Wailea, Maui. (right) A double-hulled outrigger sailing canoe sets out from Kualoa Park in Kāne'ohe Bay, O'ahu.

Pg. 65 (left) Footprints break the sand patterns on Kalalau Beach along the Nāpali Coast, Kaua'i. (right) Hanauma Bay is the remains of a volcanic crater that opened up to the

sea ages ago. It is now the most popular snorkeling spot in Hawai'i.

Pg. 66 Lava from Kīlauea Volcano flows miles to the sea both over and under the surface.

Pg. 67 The latest eruption through Puna created this river of lava leading to the ocean. Its path went through Leilani Estates destroying many homes on the Island of Hawai'i.

Pg. 68-69 This bamboo forest is on Pīpīwai Trail in Haleakalā National Park, Maui. Bamboo is actually an invasive plant in Hawai'i that spreads quickly.

Pg. 70 Episode 47, June 1986, the last time Kīlauea Volcano was fountaining.

Pg. 71 Lava rivers flow toward the ocean from Kīlauea Volcano on the Island of Hawai'i in 2018.

Pg. 72 Hala tree (pandanus) on Ke'anae Peninsula along the Hāna Coast, Maui.

Pg. 73 The massive banyan, Lahaina, Maui, provides shade for a collection of park benches. As it grows, the wide-spreading banyan supports itself with the formation of new trunks.

Pg. 74 (top left) The Ka'ahumanu Society celebrating Aloha Week in Waimea, Island of Hawai'i; (bottom left) hula dancers in Kōke'e, Kaua'i; (bottom right) an 'ukulele player in Kōke'e, Kaua'i; (top right) and a hula halau, in Hilo, Island of Hawai'i are all part of an ongoing resurgence of Hawaiian culture and arts.

Pg. 75 A Hawaiian blessing at Halema'uma'u crater on Kīlauea Volcano, Island of Hawai'i.

Pg. 76 Coconut palm trees sway on a starry night in 'Āina Haina, O'ahu.

Pg. 77 Coconut Palms frame a sunset in Kāne'ohe, O'ahu.

Pg. 78-79 The Hōkūle'a was launched in March, 1975. It has since sailed all over the world and has played a major role in the Hawaiian culture; here it is sailing into Kāne'ohe Bay.

Pg. 80 Waikīkī Beach in front of the Moana Hotel. The Moana, opened in 1901, still welcomes guests to a beach that has not changed.

Pg. 81 Ala Moana Beach Park, O'ahu, was once a marshland. Dredging and re-filling has turned it into Hawai'i's largest playground. The park was officially opened in 1934.

Pg. 82-83 Laupāhoehoe, Island of Hawai'i, was the site of a devastating tsunami on April Fool's Day, 1946. Everyday the surf pounds the lava rock shoreline.

Pg. 84-85 This panoramic shows Halema'uma'u crater with the Milky Way and a full moon at Hawai'i Volcanoes National Park on the Island of Hawai'i.

Pg. 86-87 Lava flowing into the ocean is one of Hawai'i's most fascinating and beautiful sights.

Pg. 88-89 A lone sailboat crosses the calm waters off Waikīkī, O'ahu.

Pg. 90-91 Spectacular sunsets at Kā'anapali, with the Island of Lāna'i visible in the background, happen on clear days.

Pg. 92 A rainbow lands in Kāne'ohe Bay, O'ahu.